Trinidad Colouring Book

It is well documented that, for many people (adults and children alike), colouring is a therapeutic, stress-relieving pastime.

What could be better, then, than colouring pictures of the beautiful Caribbean island of Trinidad? Imagine yourself soaking up the sun on a palm-fringed beach, watching incredible hummingbirds, or enjoying a rum tasting at the Angostura distillery.

Unlike most other colouring books which are usually filled with whimsical and cartoon images, mine are full of real pictures.

In this case, the colouring pages were created from photographs I took during our two-week stay in Trinidad. We hired a car and explored every corner of this vibrant and varied island. Within this book, you will find images of some of the amazing flora and fauna to be found here, especially at the Asa Wright Centre, the Pointe-a-Pierre Wildfowl Trust, and Yerette, home of the hummingbird. You will also find pictures of Maracas Bay, Las Cuevas Beach, the island's capital, Port of Spain, and Waterloo Temple in the Sea, plus many more. There are drawings here to inspire you and get your creative juices flowing!!

Grab your favourite pens or pencils and let your imagination and creativity run riot. I use high quality fine-tip felt pens for the details, and coloured pencils for the larger areas, but the choice is yours. Some people like to put a water colour wash across the whole picture before they begin. It's your creation. It's up to you!

Cut out your finished work and display it somewhere as in inspiration to travel further for longer, or as a reminder of places you've already been to.

Keep in touch with me at Happy Days Travel Blog or on social media:

@happydaystravelblog @happydayswriter

Show me your creations, follow my travels, and tell me about yours!

Copyright © 2019 Happy Days Publishing - All Rights Reserved. Further information from https://happydaystravelblog.com

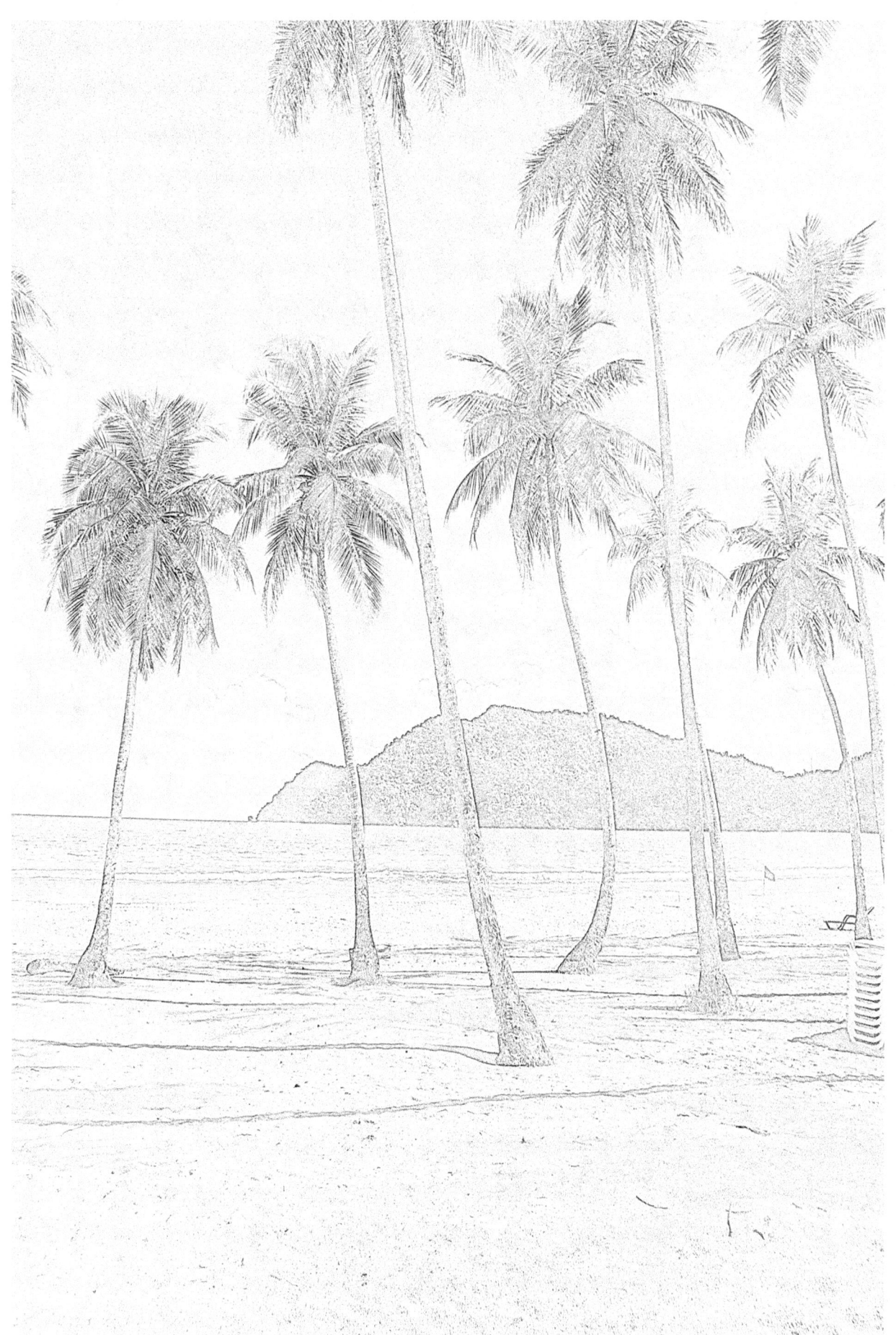

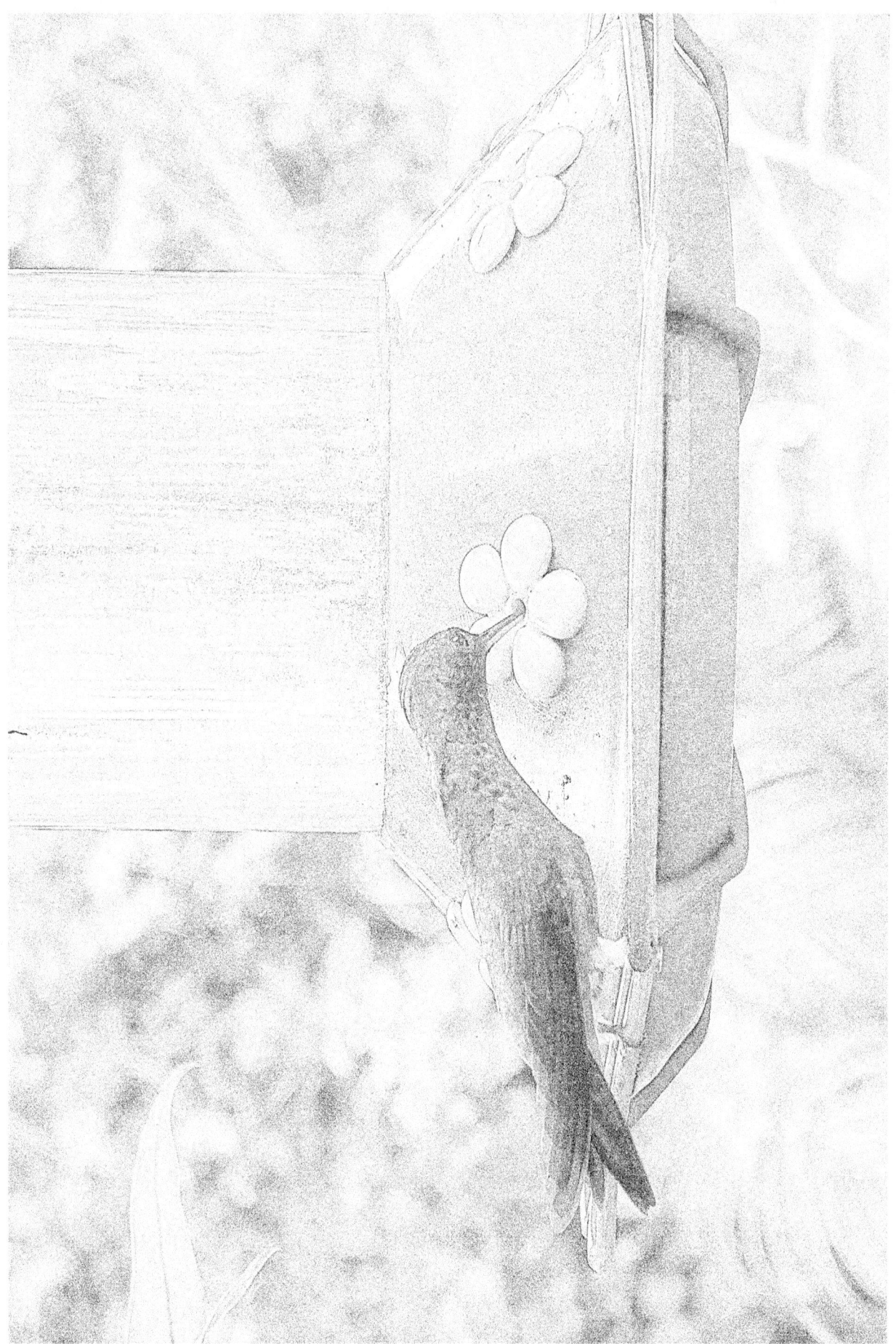

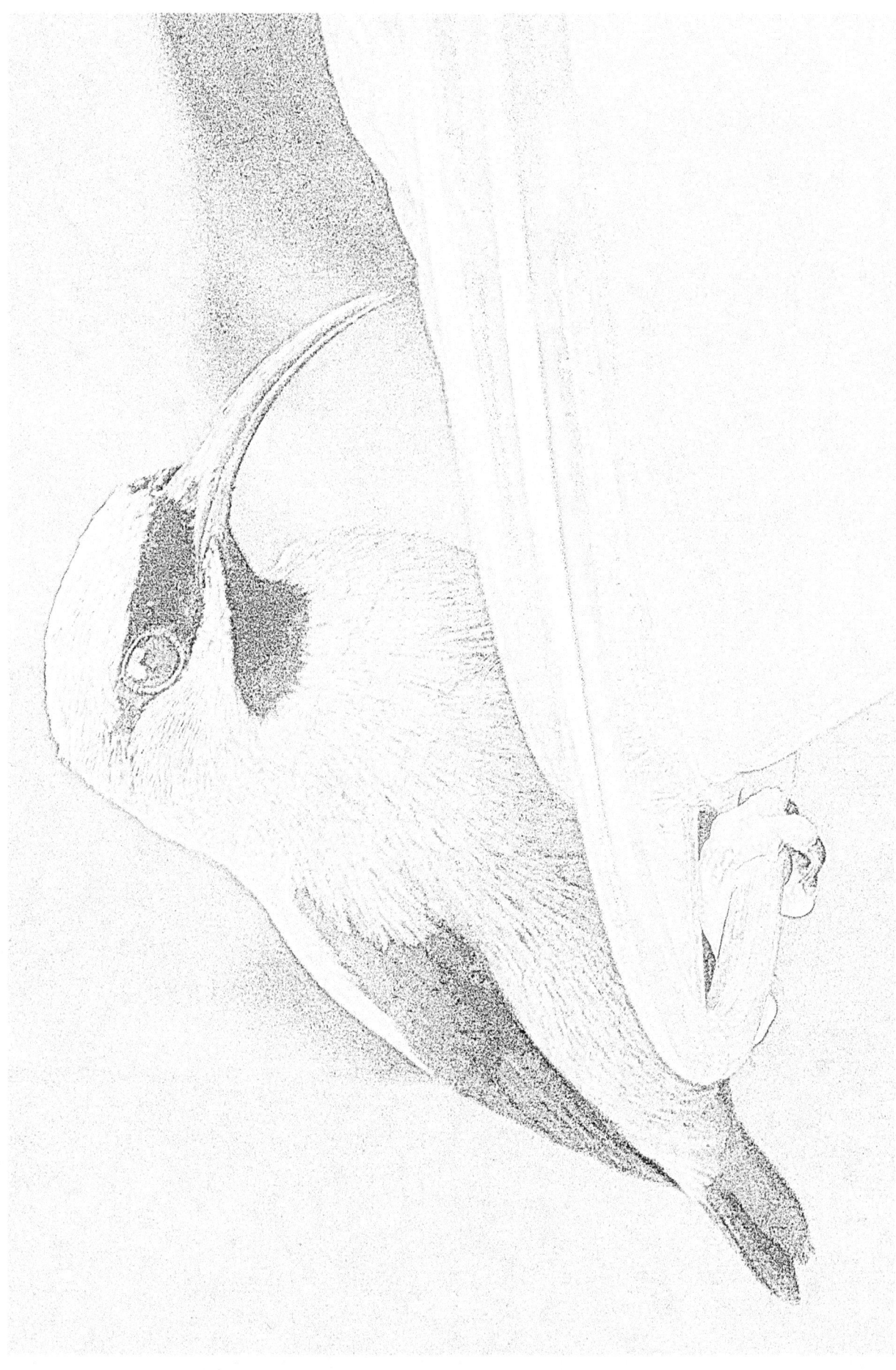

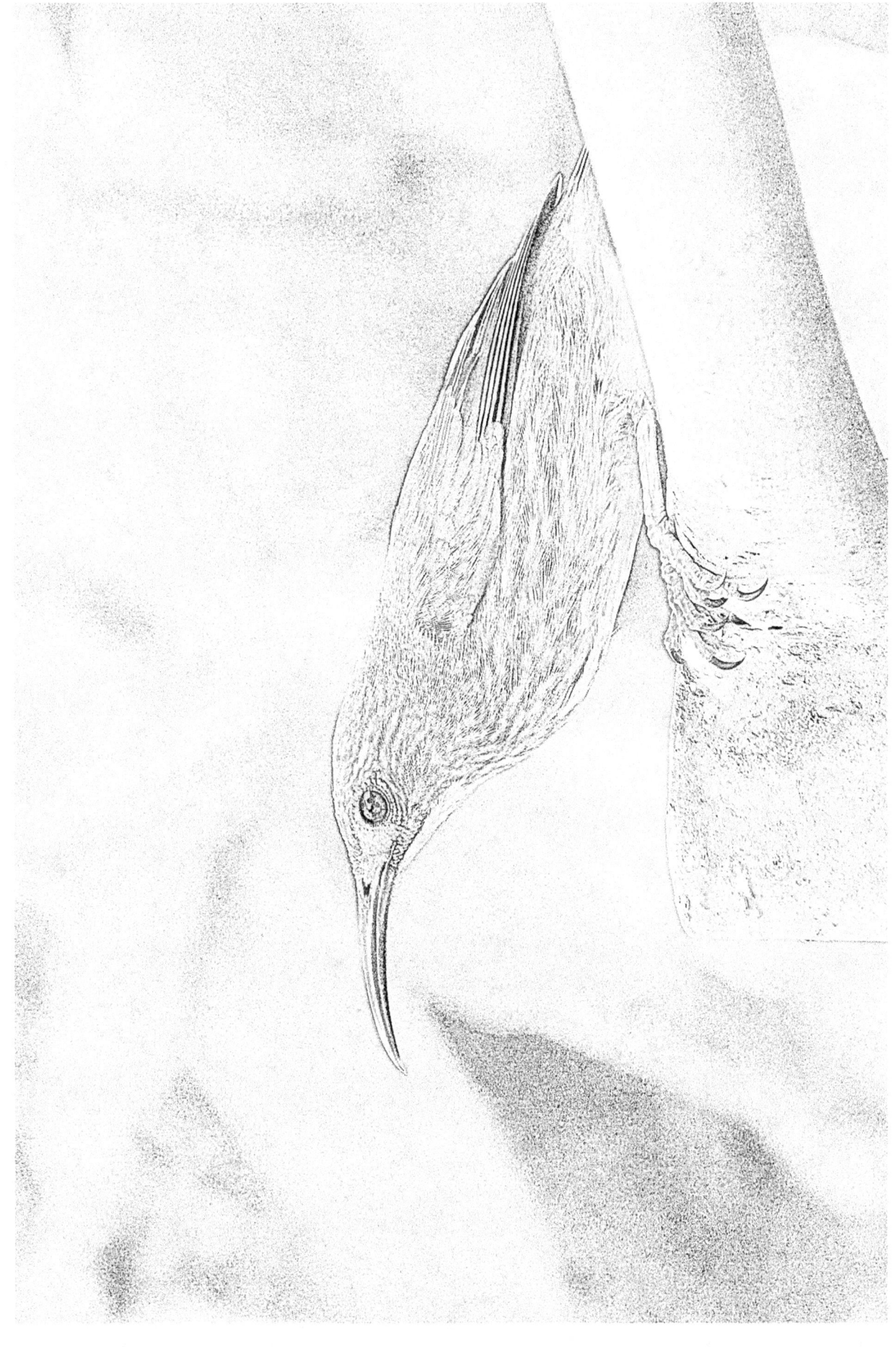

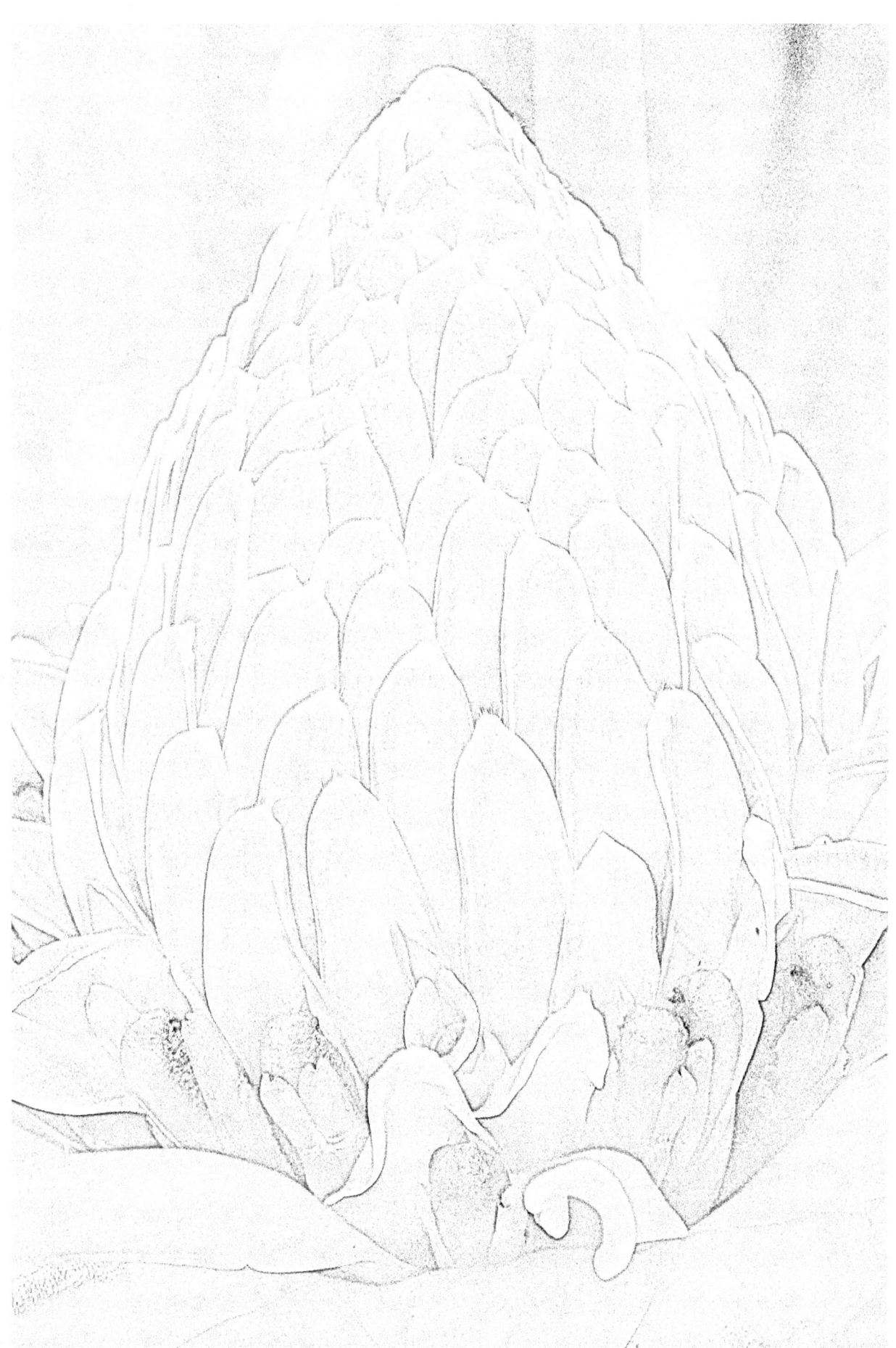

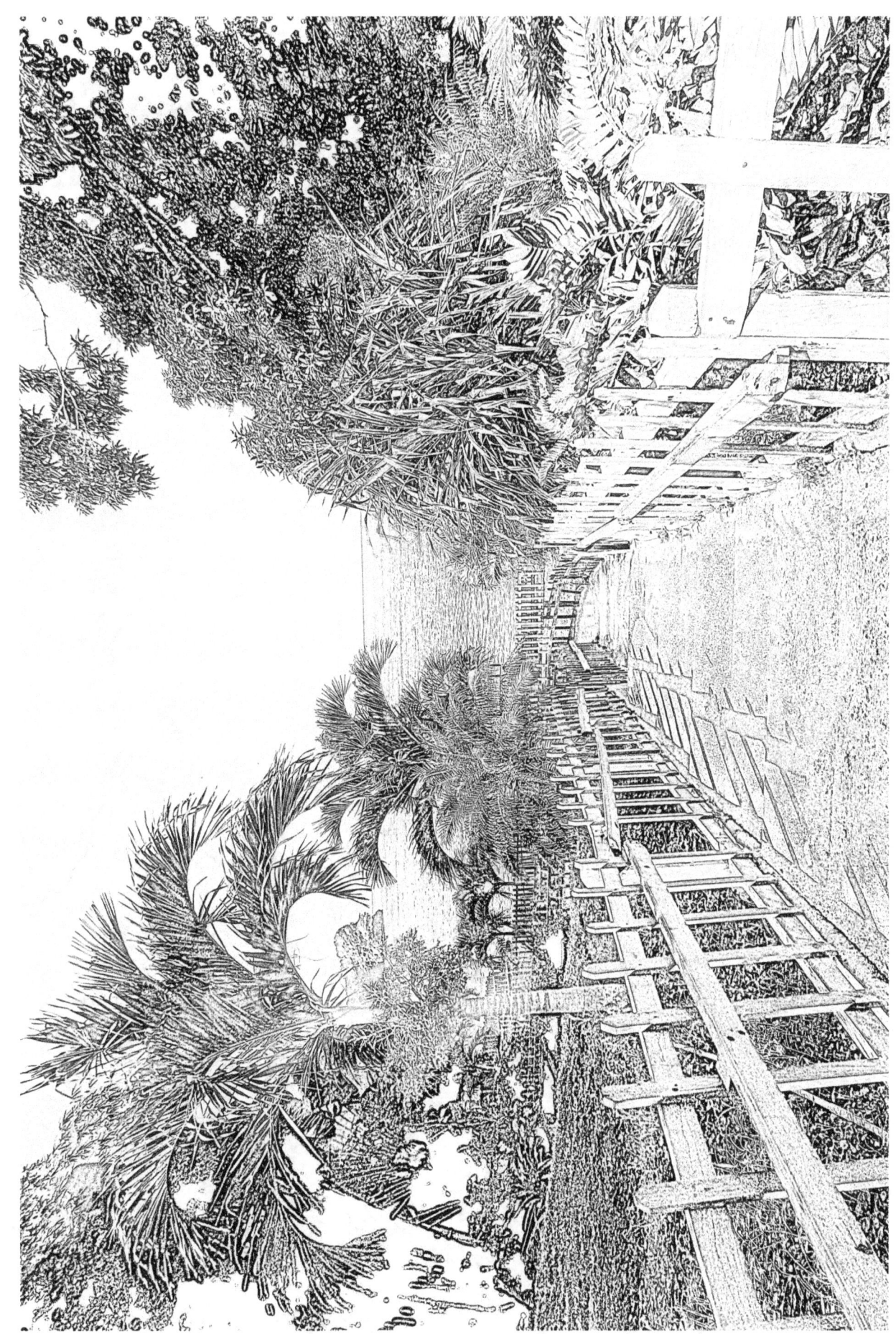

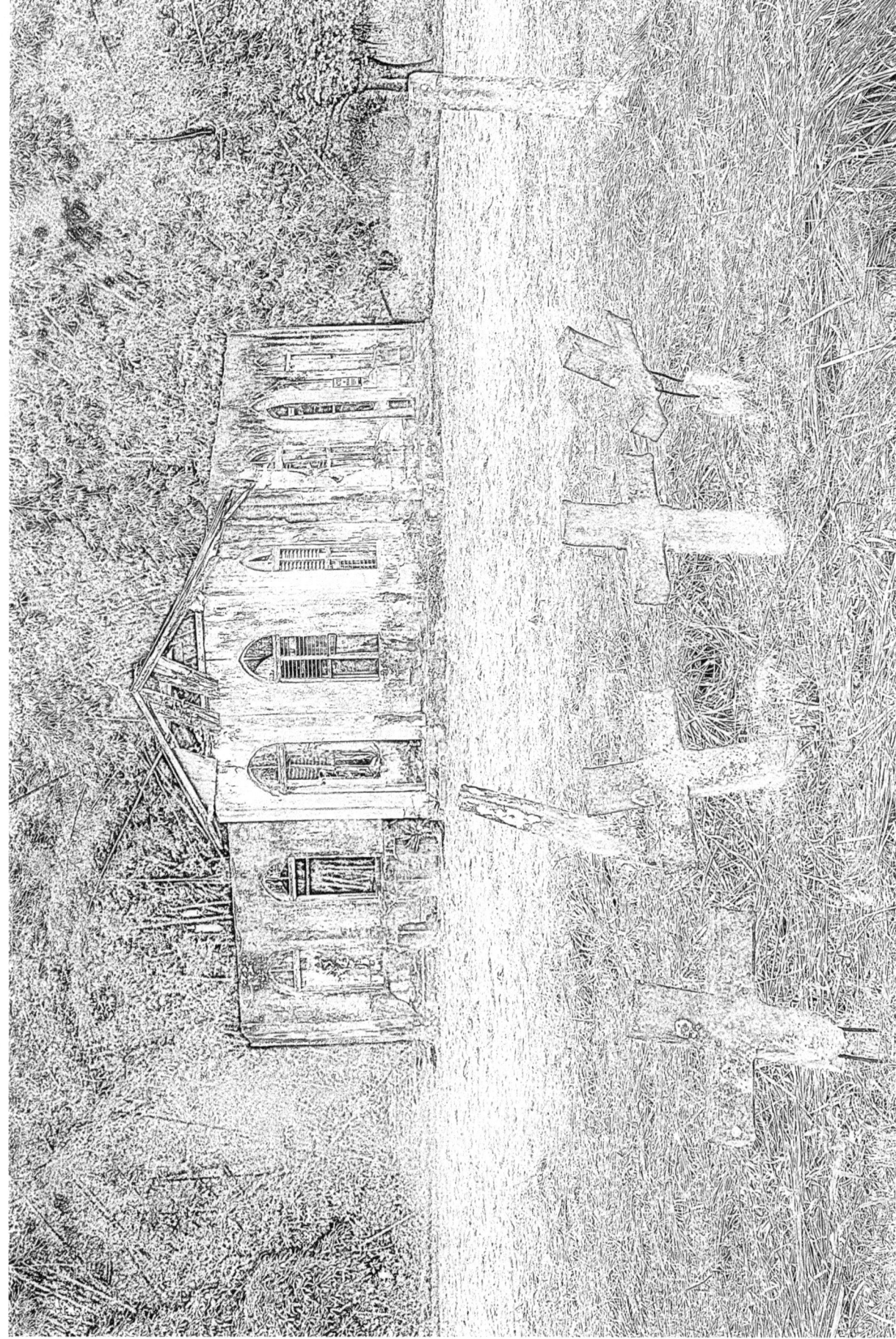

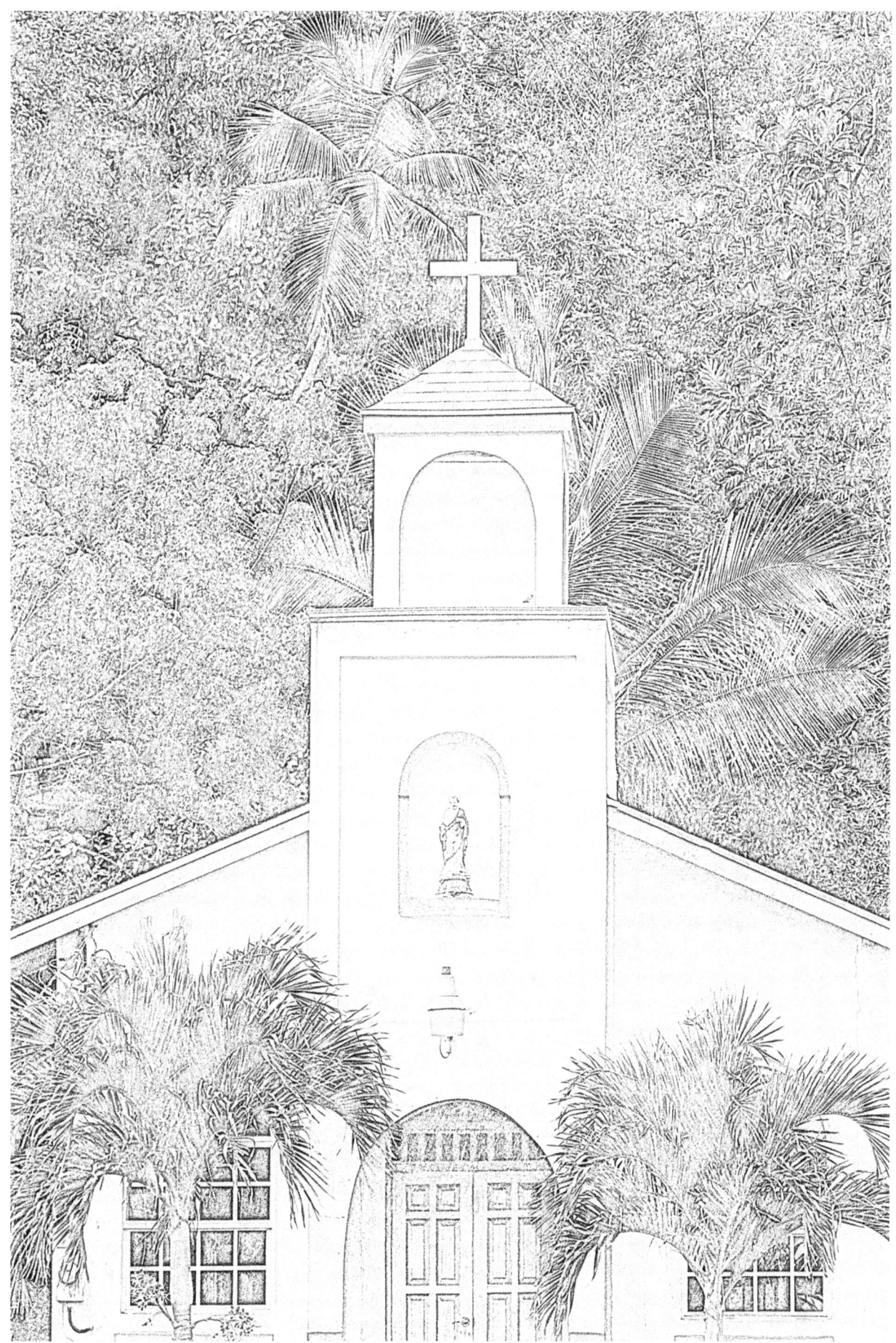

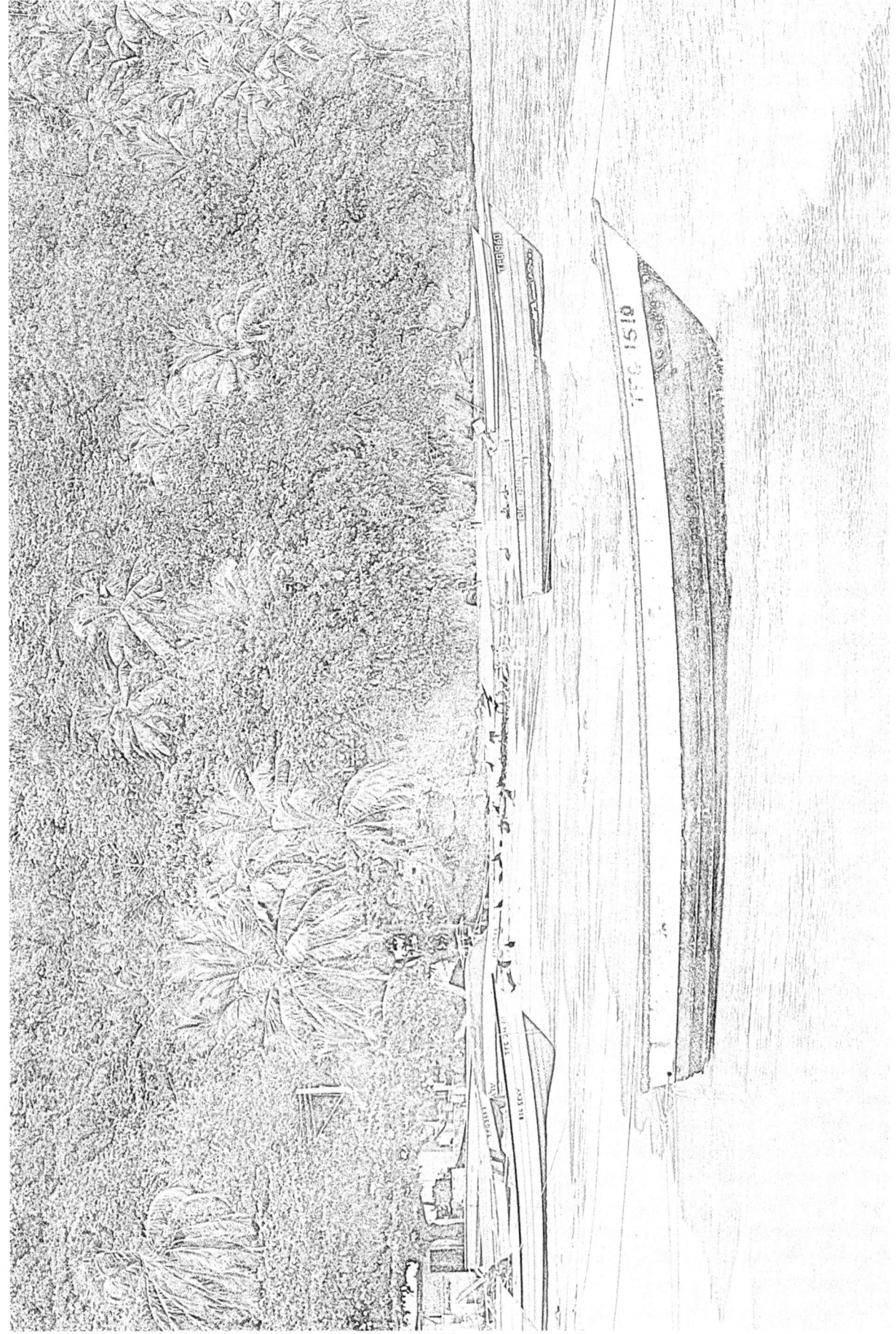

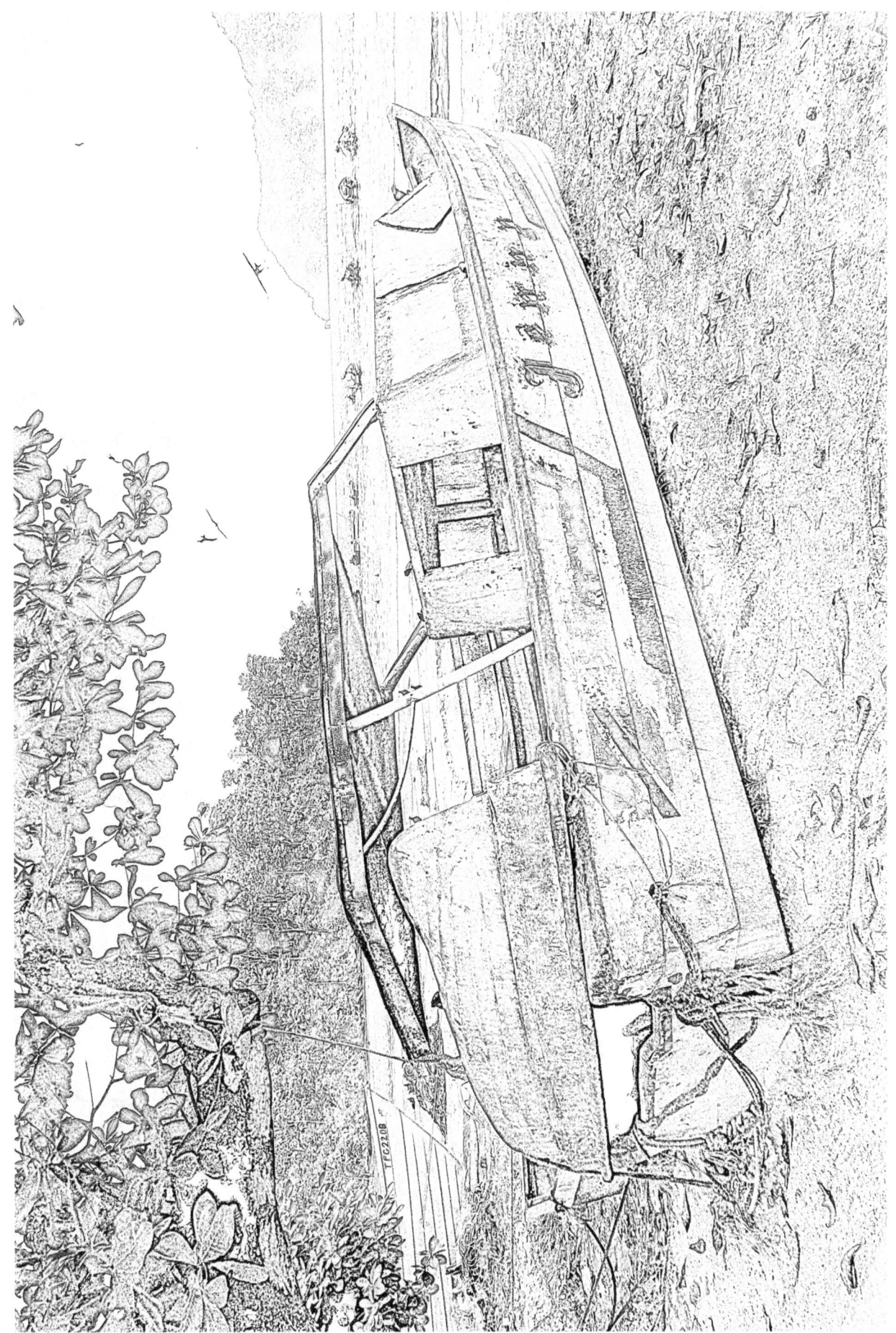

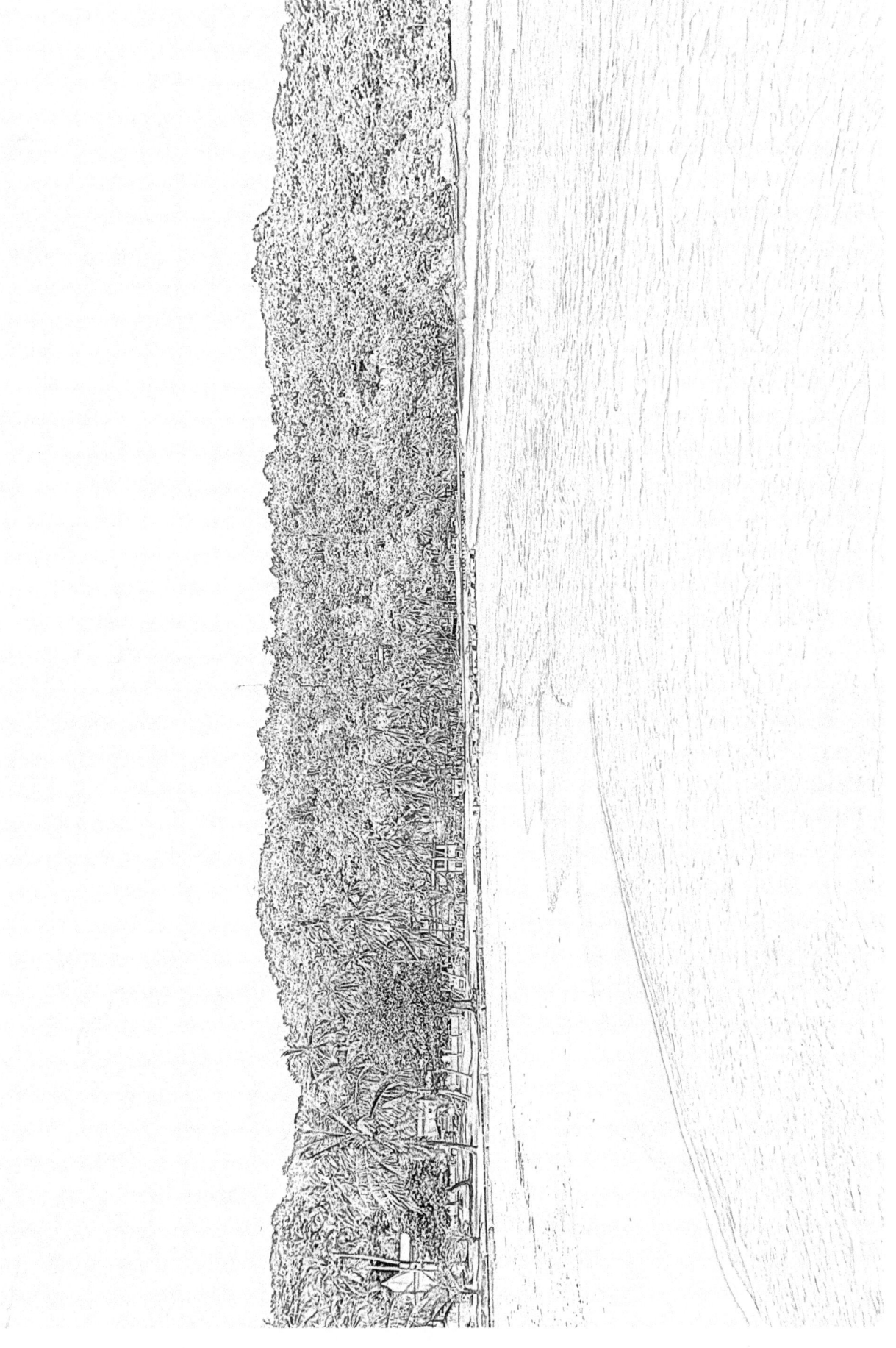

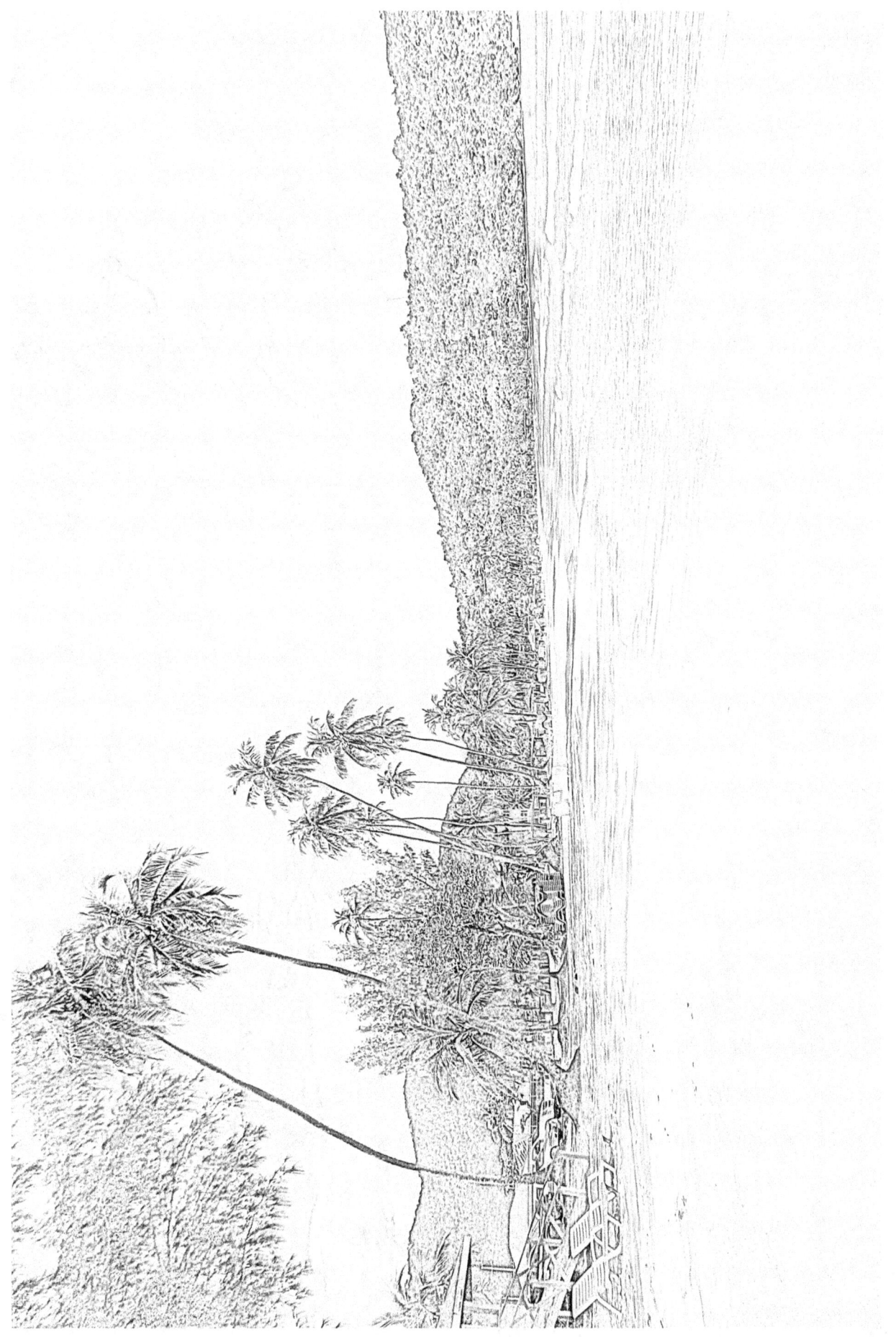

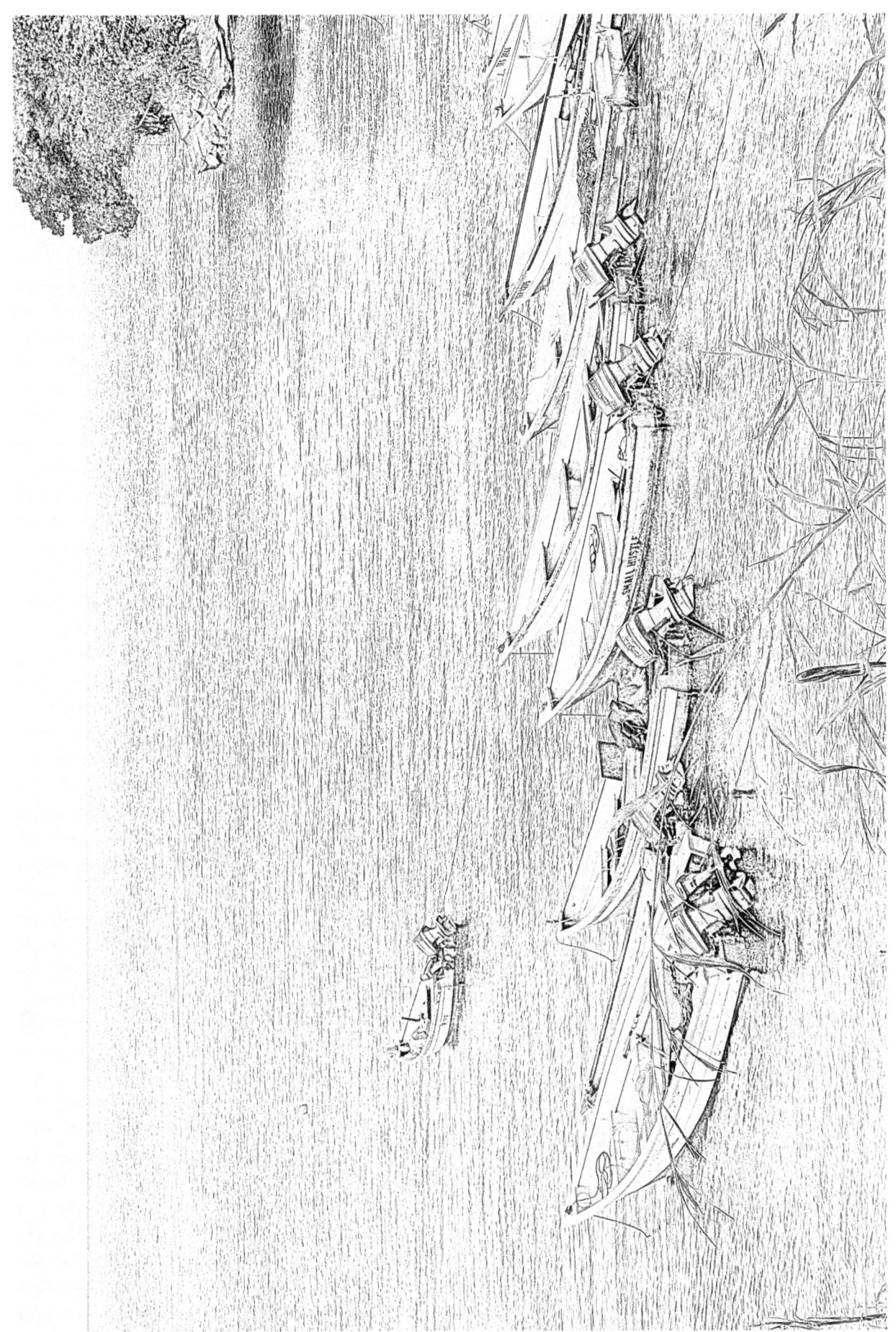

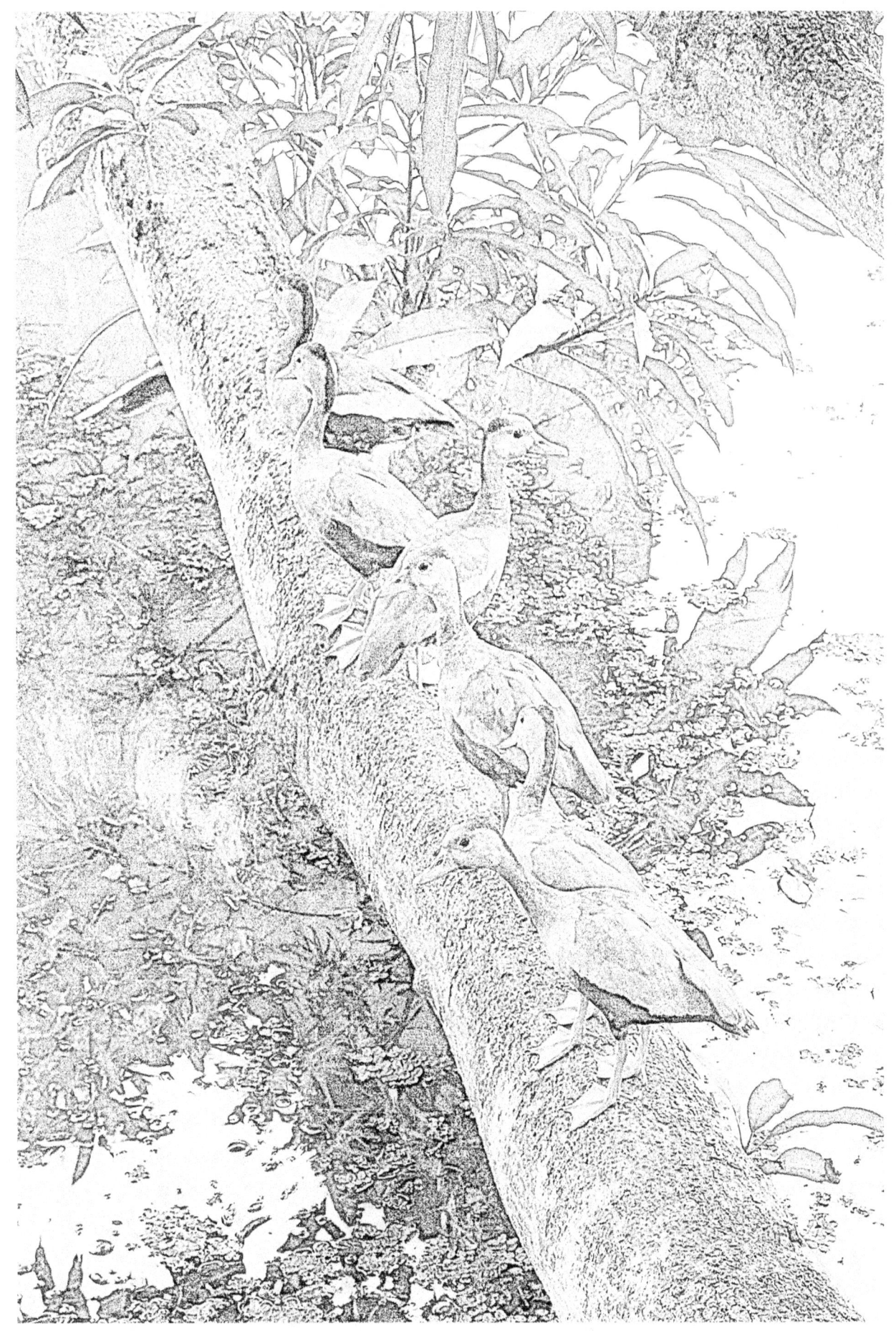

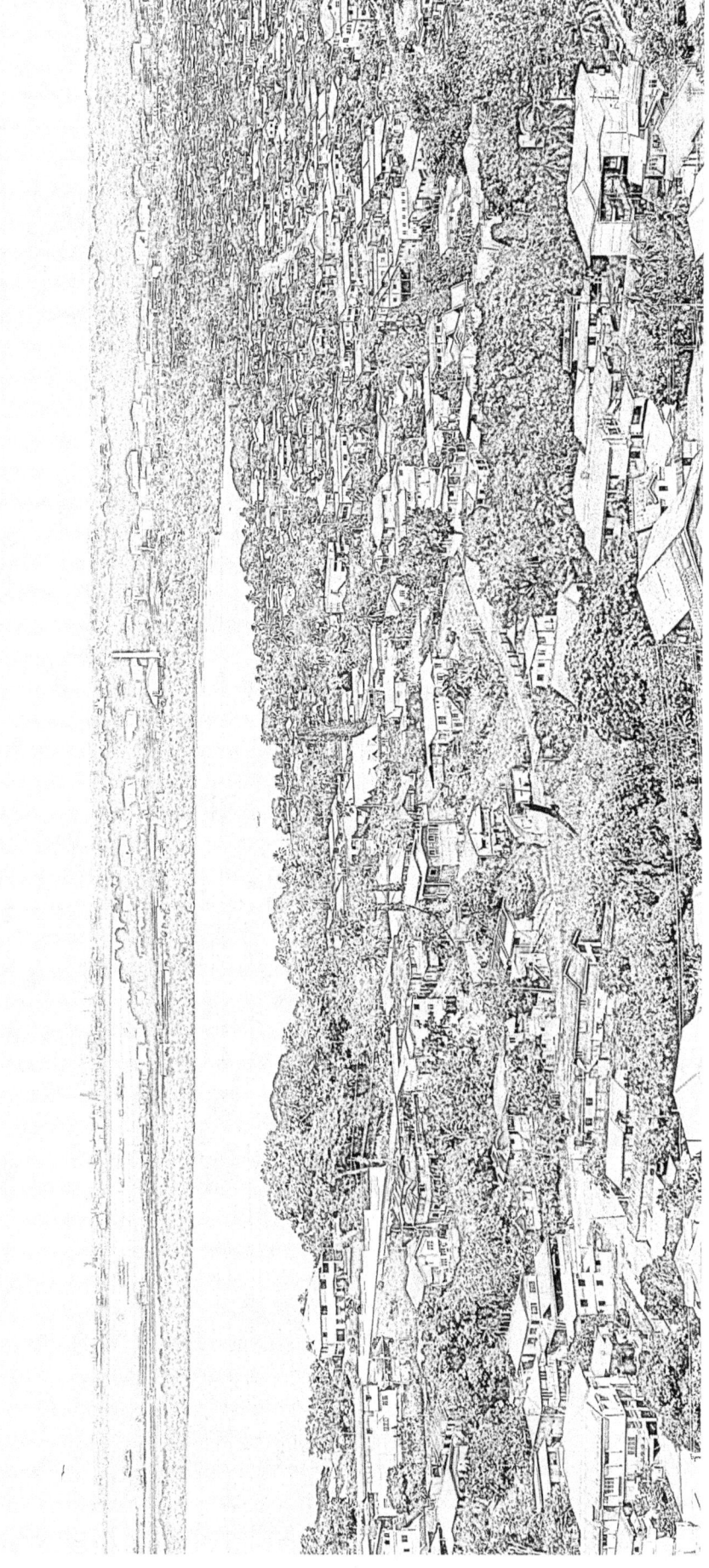

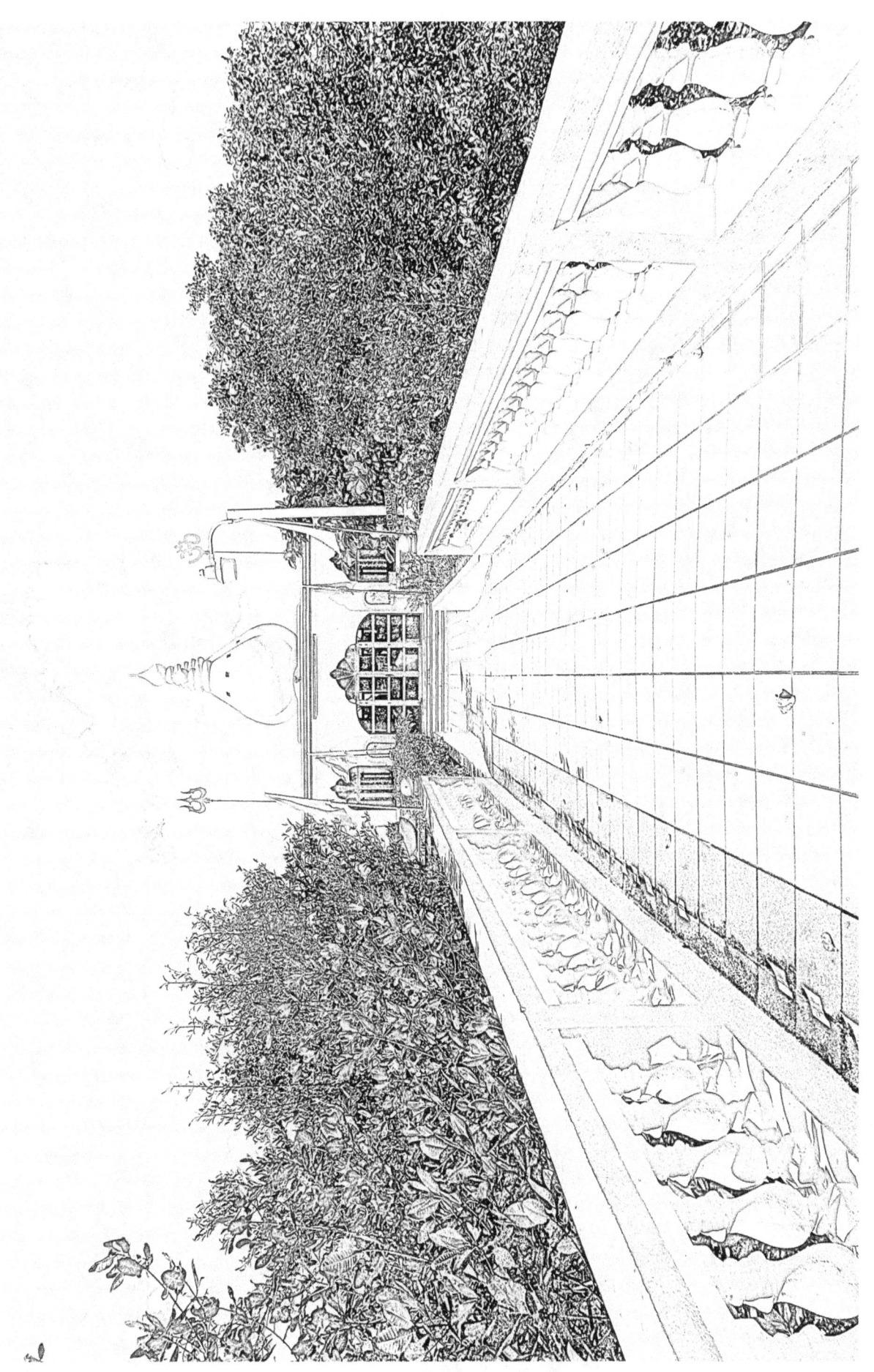

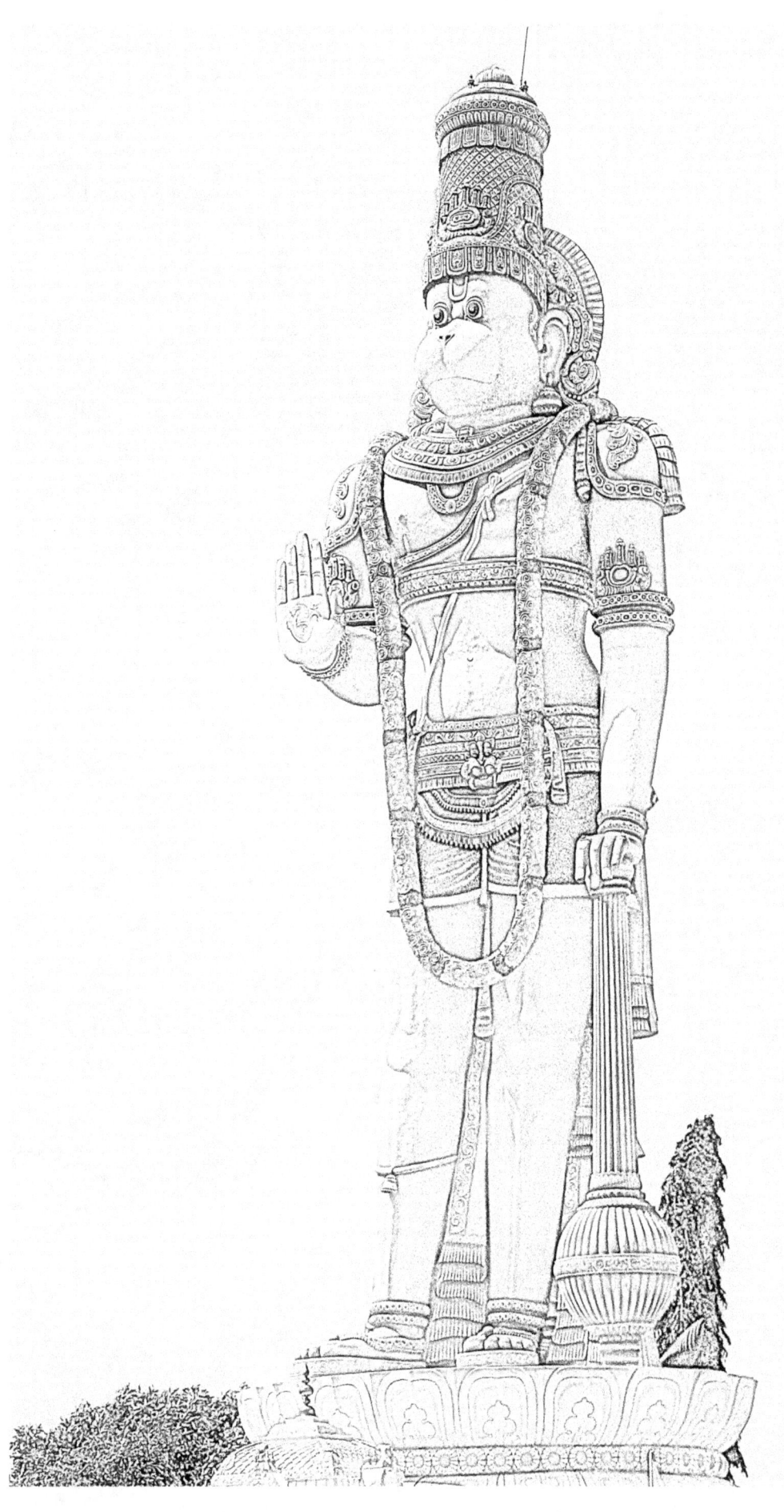

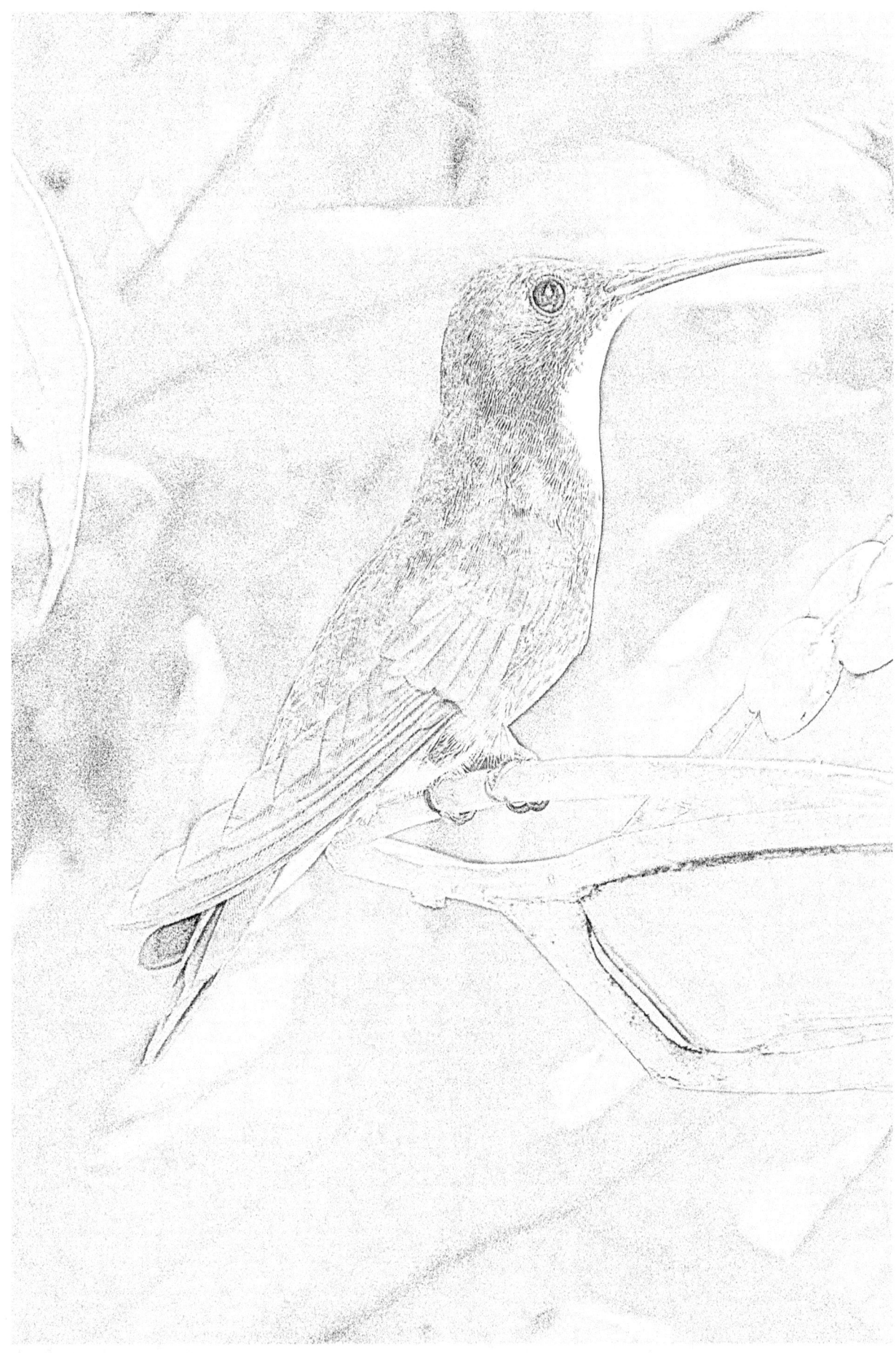

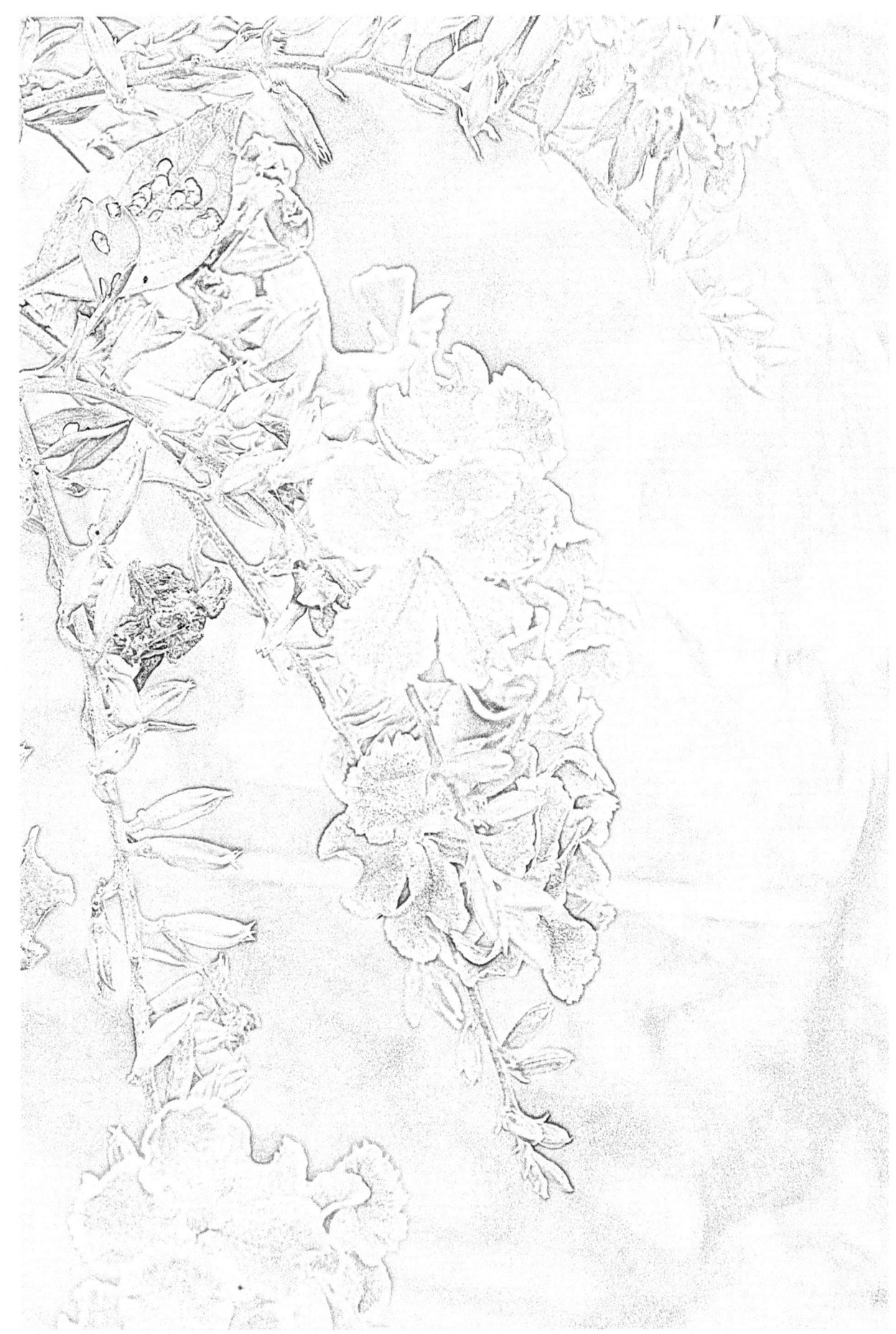

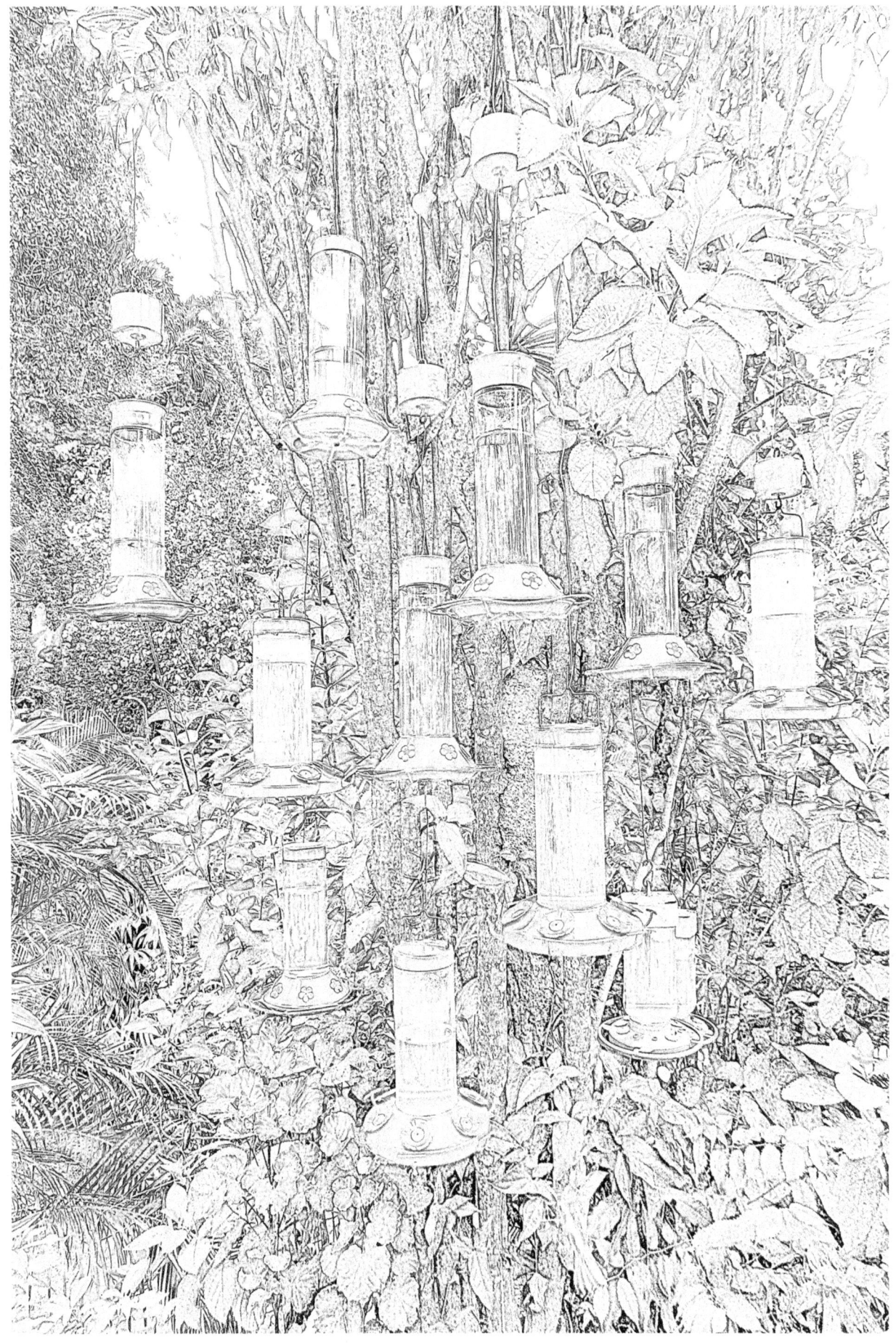

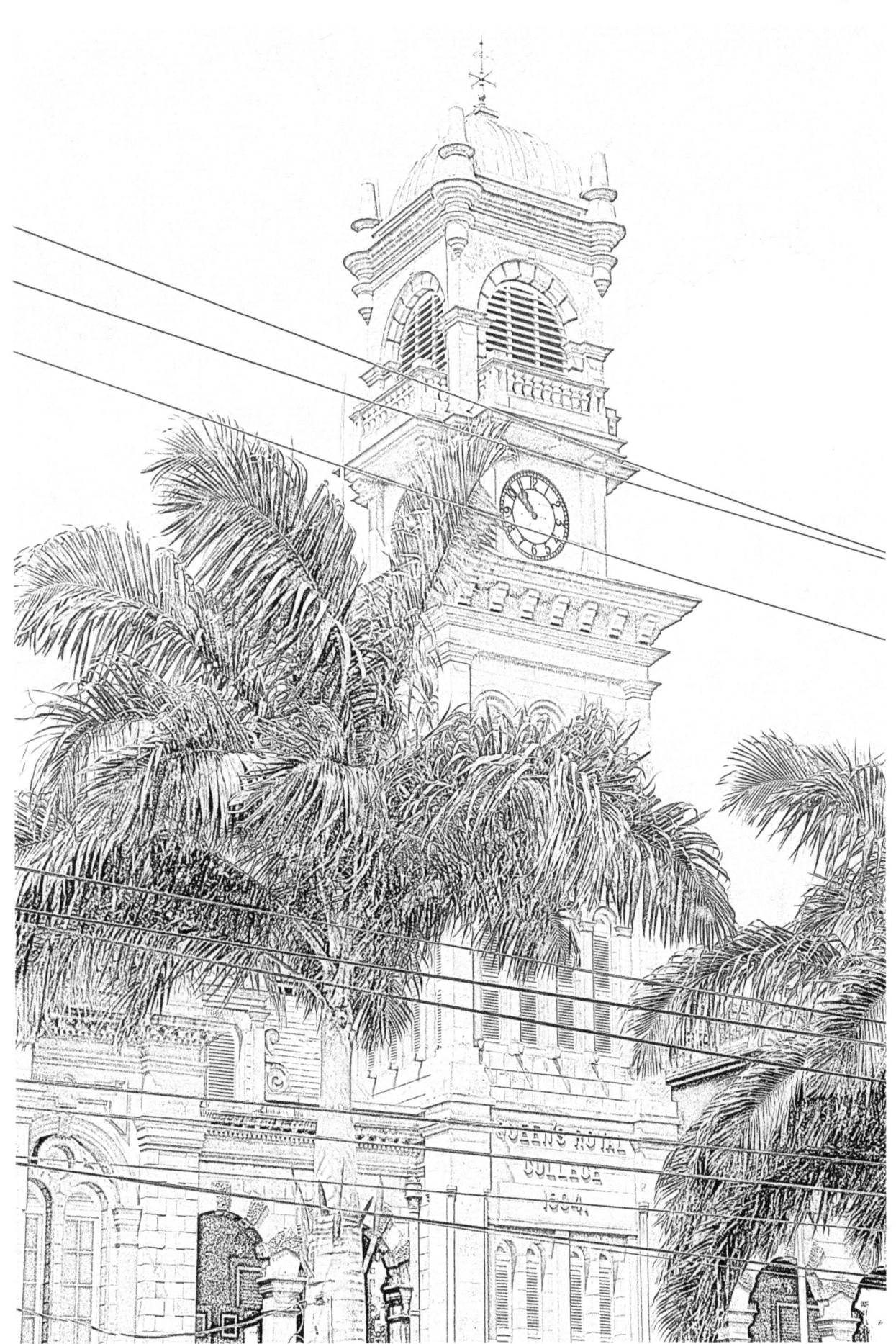

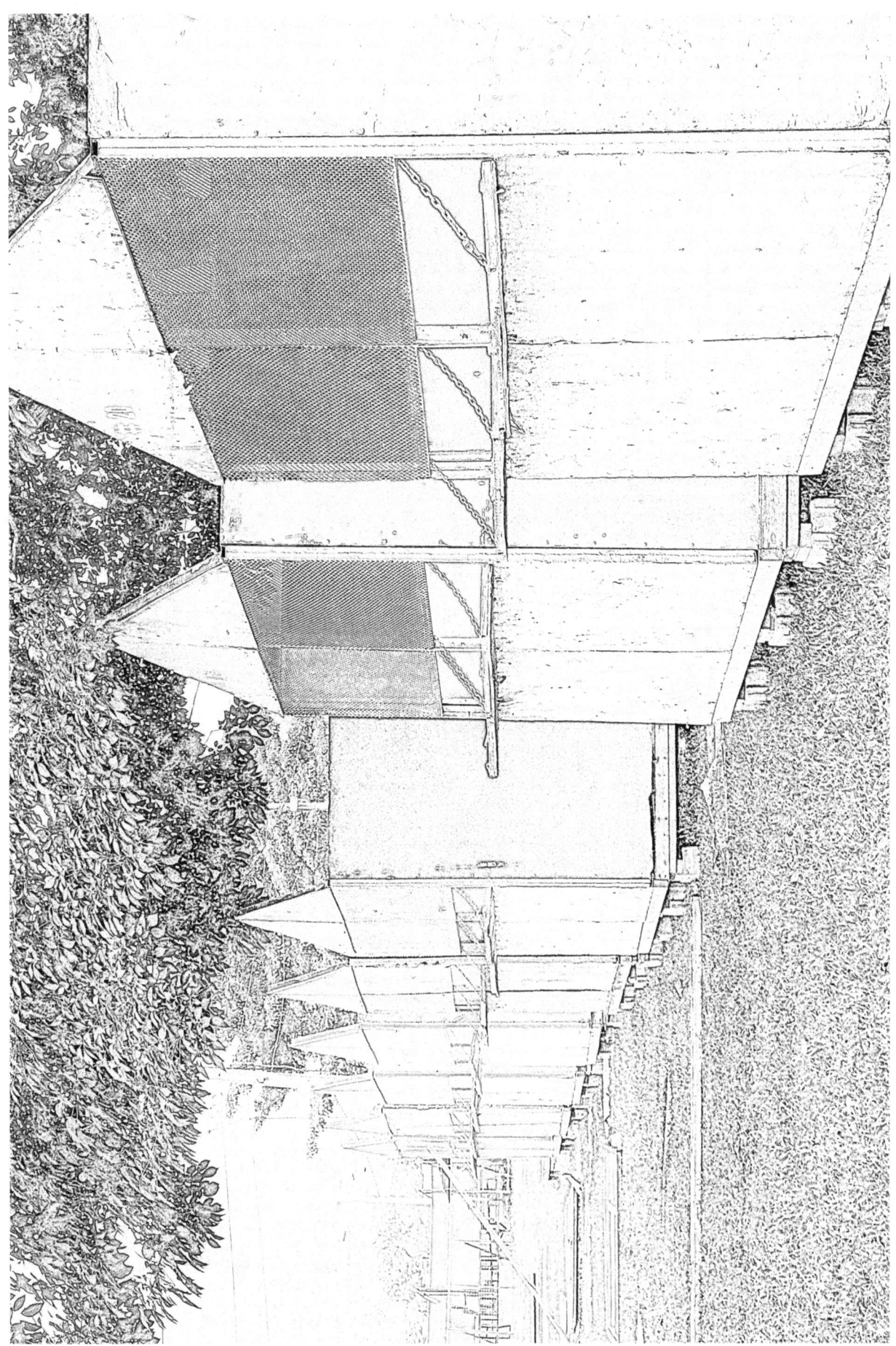

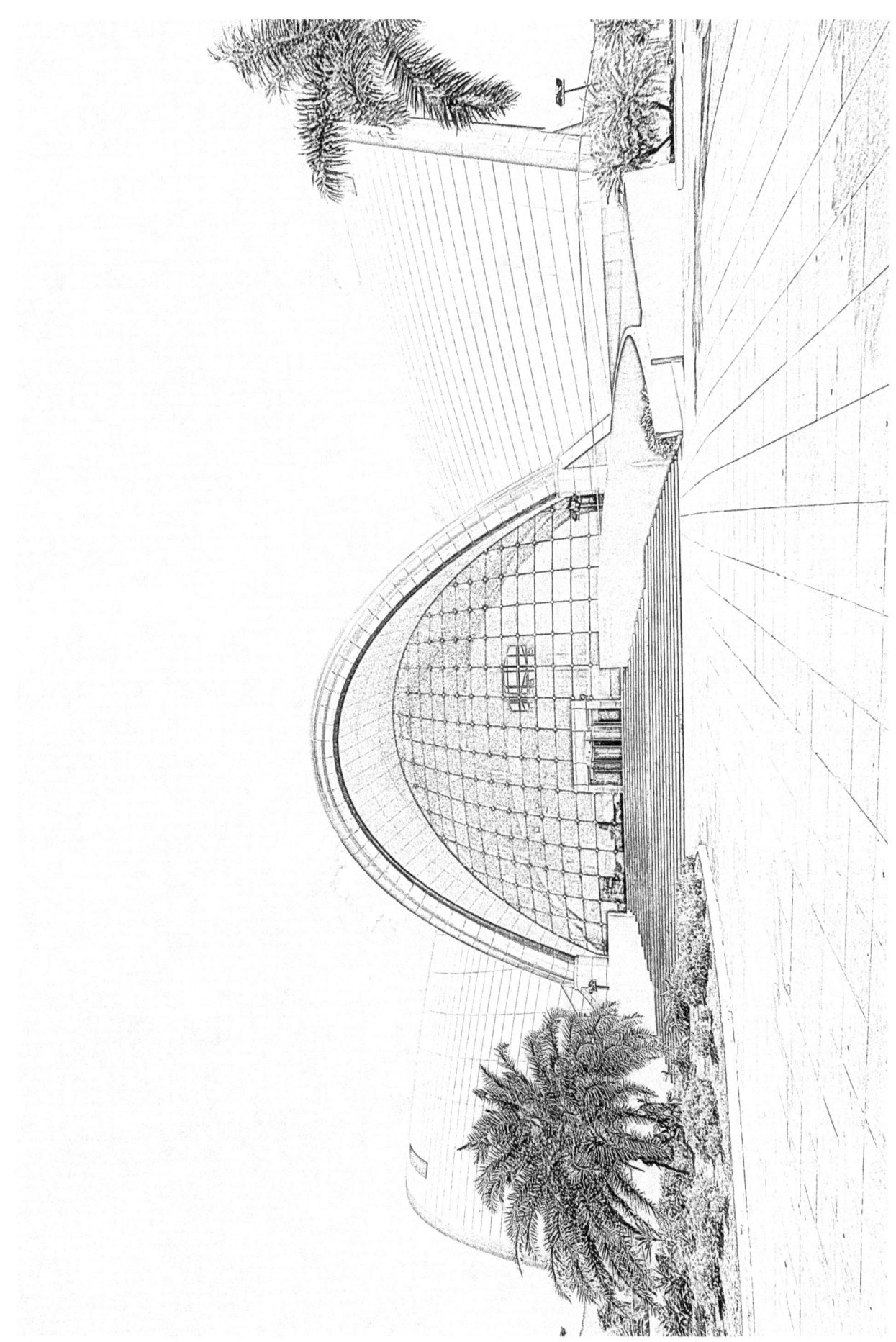

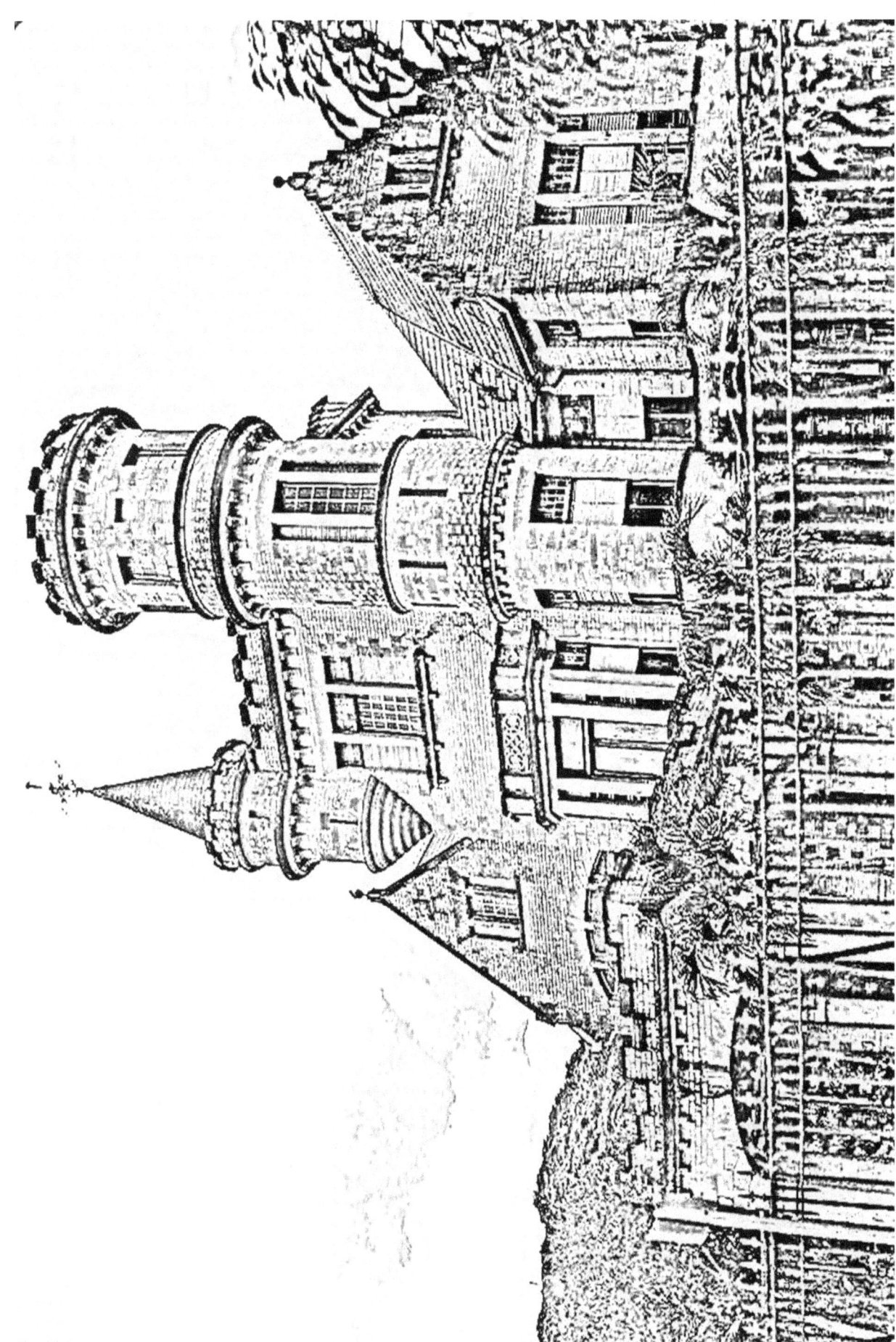